Wales

DATE DUE

out
ales

y

wen.

s
l

yth
y
h

on
llaen
ck
ait
o

D1331756

GRAFFEG

Introduction

In all of its moods the coastline of Wales, stretching for 750 miles (1,200 km) around headland, harbour, bluff, cove and estuary, and dotted with more than 40 magical islands, is a photographer's dream.

From the twenty-first century sophistication of Cardiff Bay to the elegant Victorian splendour of Llandudno; from the rugged limestone cliffs of the Glamorgan Heritage Coast to the wave-pounded sand flats of Newgale in Pembrokeshire, each new stretch of its shoreline offers a dramatic contrast to the last.

Colonised on its wilder extremities by the Manx Shearwater, Guillemot or Puffin, studded with history in the shape of traditional fishing villages, medieval castles and time-honoured seaside resorts, and often embellished with a panoramic estuary or mountainous backdrop, Wales's seaside frontier boasts a rich diversity of natural and man-made attractions.

Through the creation of national parks, nature, wildlife and marine reserves, and the designation of specially-protected environmental status, those who marshal Wales's coast perform a careful balancing trick between the often conflicting demands of nature and of man. As a result fragile species of plant and wildlife, such as the bluebells of Skomer or the bottlenose dolphins of Cardigan Bay, live side by side with the holidaymakers and adventure sports enthusiasts who are so important to the Welsh economy.

In pictures and words this minibook takes the reader on a voyage of discovery around the inspiring coastline of Wales.

Skomer

Spring covers much of the three square miles of Wales's third largest island with a carpet of wild flowers. Skomer, lying just off the Pembrokeshire coast amid the coral of the nation's only marine nature reserve, is a haven for half a million seabirds from the Manx Shearwater and the Puffin, to the Guillemot, Kittiwake and Razorbill. A Wildlife Trust warden watches over them for nine months of the year.

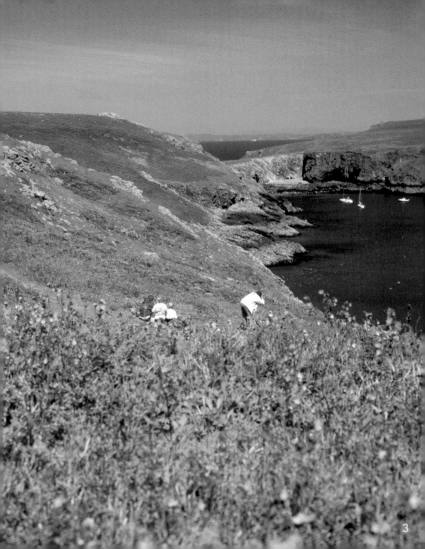

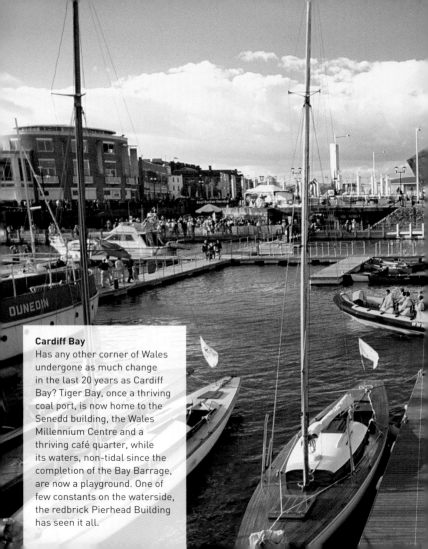

Cardiff Bay
Has any other corner of Wales
undergone as much change
in the last 20 years as Cardiff
Bay? Tiger Bay, once a thriving
coal port, is now home to the
Senedd building, the Wales
Millennium Centre and a
thriving café quarter, while
its waters, non-tidal since the
completion of the Bay Barrage,
are now a playground. One of
few constants on the waterside,
the redbrick Pierhead Building
has seen it all.

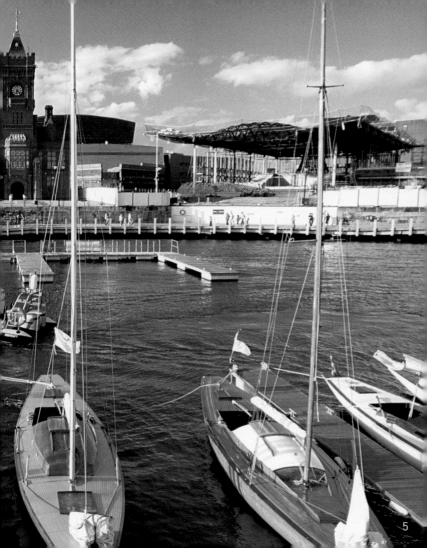

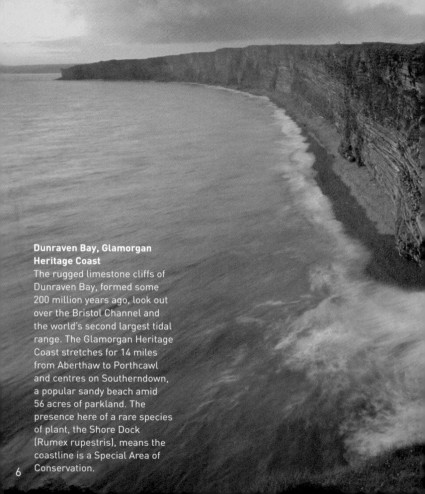

Dunraven Bay, Glamorgan Heritage Coast
The rugged limestone cliffs of Dunraven Bay, formed some 200 million years ago, look out over the Bristol Channel and the world's second largest tidal range. The Glamorgan Heritage Coast stretches for 14 miles from Aberthaw to Porthcawl and centres on Southerndown, a popular sandy beach amid 56 acres of parkland. The presence here of a rare species of plant, the Shore Dock (Rumex rupestris), means the coastline is a Special Area of Conservation.

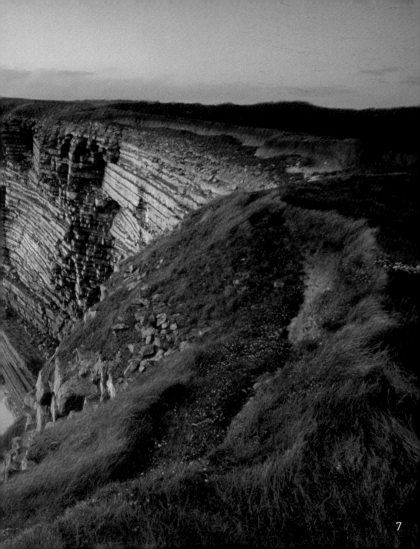

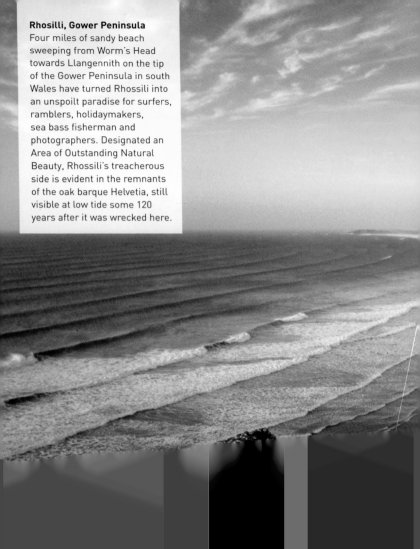

Rhosilli, Gower Peninsula
Four miles of sandy beach
sweeping from Worm's Head
towards Llangennith on the tip
of the Gower Peninsula in south
Wales have turned Rhossili into
an unspoilt paradise for surfers,
ramblers, holidaymakers,
sea bass fisherman and
photographers. Designated an
Area of Outstanding Natural
Beauty, Rhossili's treacherous
side is evident in the remnants
of the oak barque Helvetia, still
visible at low tide some 120
years after it was wrecked here.

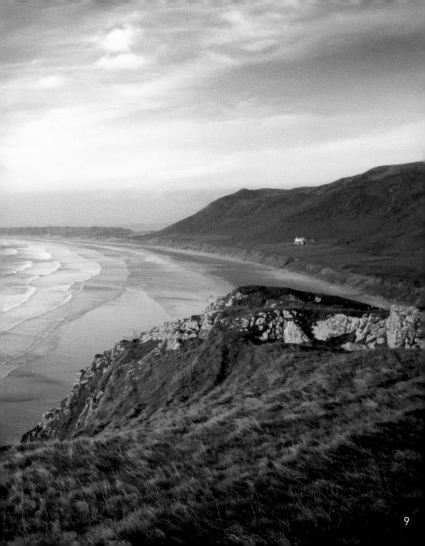

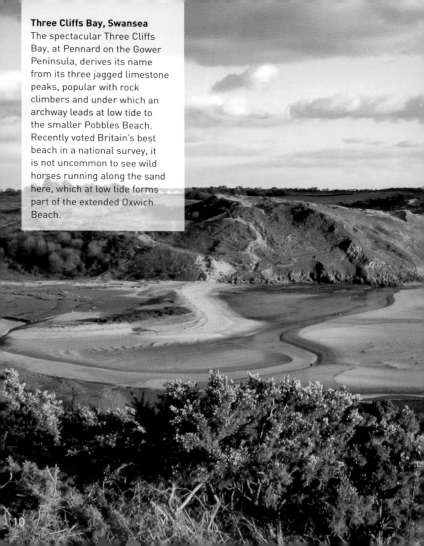

Three Cliffs Bay, Swansea

The spectacular Three Cliffs Bay, at Pennard on the Gower Peninsula, derives its name from its three jagged limestone peaks, popular with rock climbers and under which an archway leads at low tide to the smaller Pobbles Beach. Recently voted Britain's best beach in a national survey, it is not uncommon to see wild horses running along the sand here, which at low tide forms part of the extended Oxwich Beach.

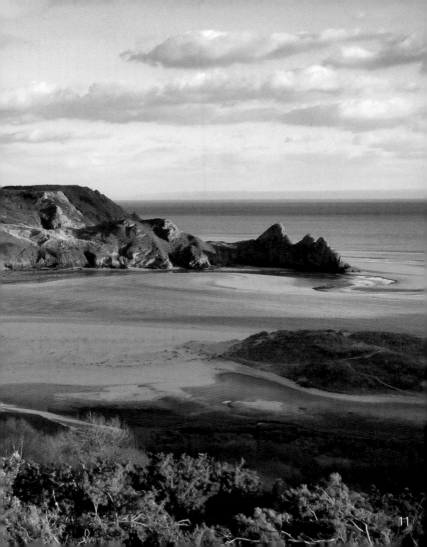

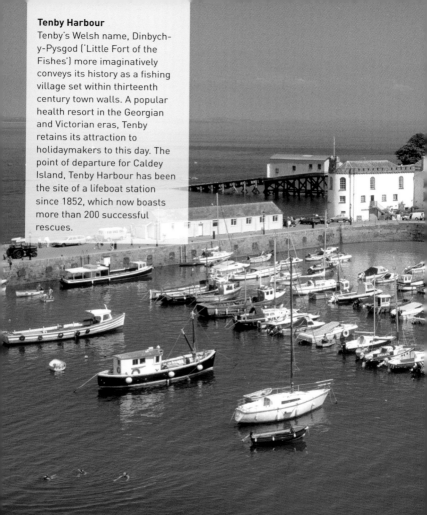

Tenby Harbour

Tenby's Welsh name, Dinbych-y-Pysgod ('Little Fort of the Fishes') more imaginatively conveys its history as a fishing village set within thirteenth century town walls. A popular health resort in the Georgian and Victorian eras, Tenby retains its attraction to holidaymakers to this day. The point of departure for Caldey Island, Tenby Harbour has been the site of a lifeboat station since 1852, which now boasts more than 200 successful rescues.

12

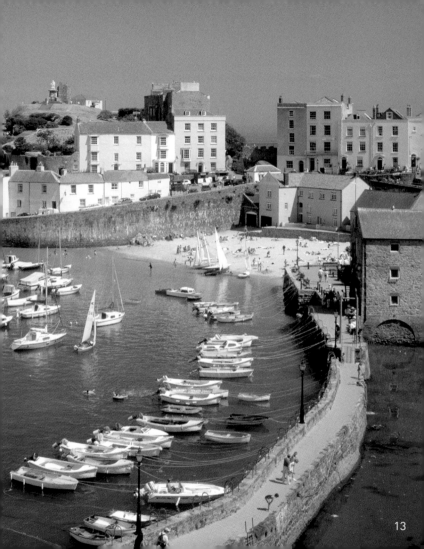

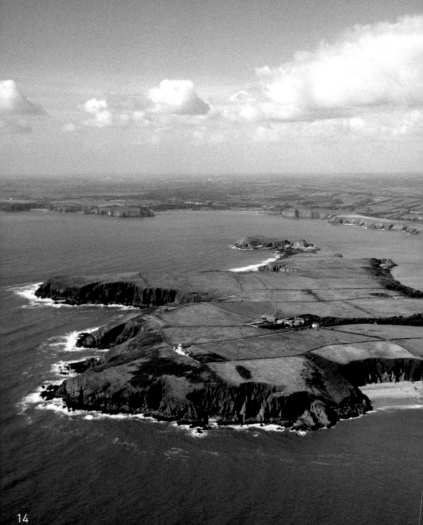

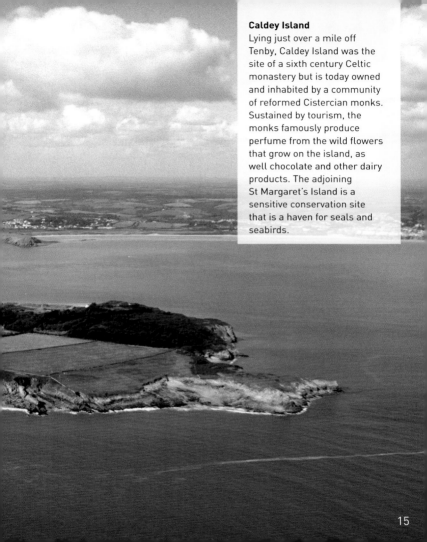

Caldey Island

Lying just over a mile off Tenby, Caldey Island was the site of a sixth century Celtic monastery but is today owned and inhabited by a community of reformed Cistercian monks. Sustained by tourism, the monks famously produce perfume from the wild flowers that grow on the island, as well chocolate and other dairy products. The adjoining St Margaret's Island is a sensitive conservation site that is a haven for seals and seabirds.

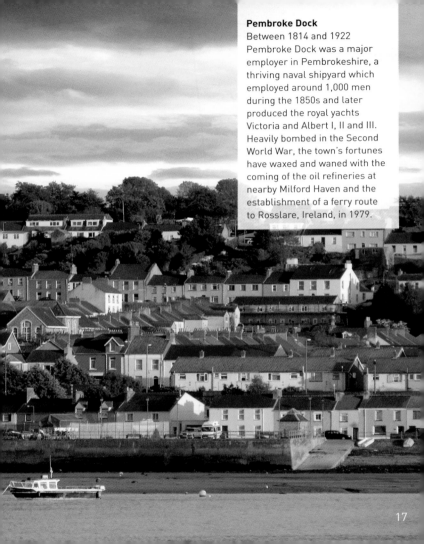

Pembroke Dock

Between 1814 and 1922 Pembroke Dock was a major employer in Pembrokeshire, a thriving naval shipyard which employed around 1,000 men during the 1850s and later produced the royal yachts Victoria and Albert I, II and III. Heavily bombed in the Second World War, the town's fortunes have waxed and waned with the coming of the oil refineries at nearby Milford Haven and the establishment of a ferry route to Rosslare, Ireland, in 1979.

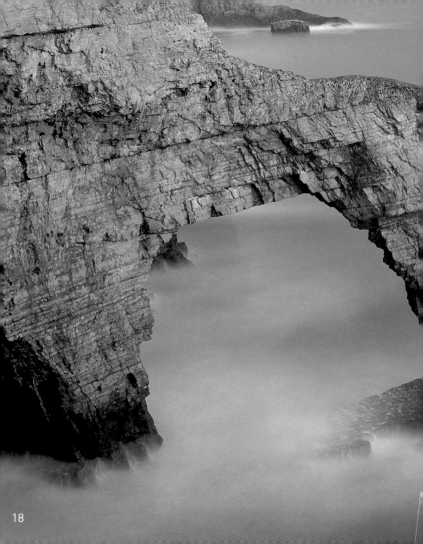

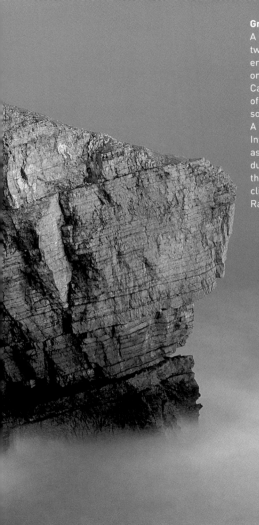

Green Bridge, Pembrokeshire
A natural arch formed some
two million years ago by
erosion in the Stack Rocks
on St Govan's Headland near
Castlemartin, the Green Bridge
of Wales rises spectacularly
some 80ft above the water.
A Site of Special Scientific
Interest, the Stack Rocks qualify
as a Special Protection Area
due to the number of choughs
that breed here, as well as its
cliff-face colonies of Guillemots,
Razorbills and Kittiwakes.

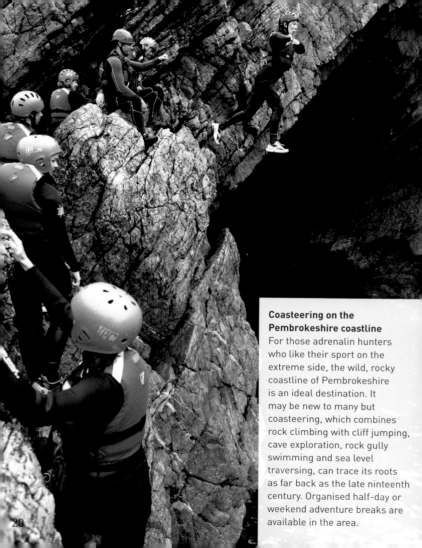

**Coasteering on the
Pembrokeshire coastline**
For those adrenalin hunters
who like their sport on the
extreme side, the wild, rocky
coastline of Pembrokeshire
is an ideal destination. It
may be new to many but
coasteering, which combines
rock climbing with cliff jumping,
cave exploration, rock gully
swimming and sea level
traversing, can trace its roots
as far back as the late ninteenth
century. Organised half-day or
weekend adventure breaks are
available in the area.

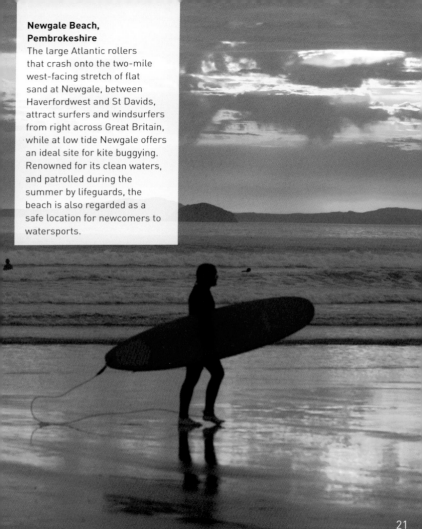

Newgale Beach, Pembrokeshire

The large Atlantic rollers that crash onto the two-mile west-facing stretch of flat sand at Newgale, between Haverfordwest and St Davids, attract surfers and windsurfers from right across Great Britain, while at low tide Newgale offers an ideal site for kite buggying. Renowned for its clean waters, and patrolled during the summer by lifeguards, the beach is also regarded as a safe location for newcomers to watersports.

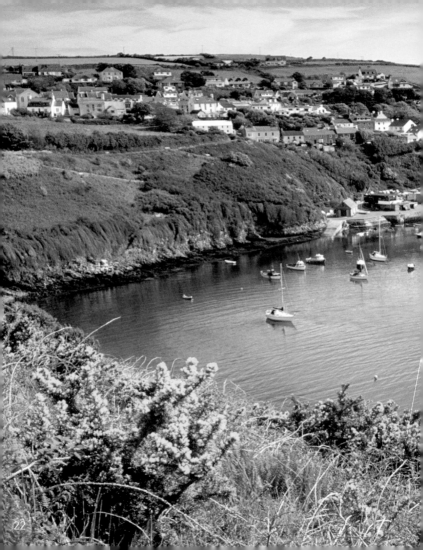

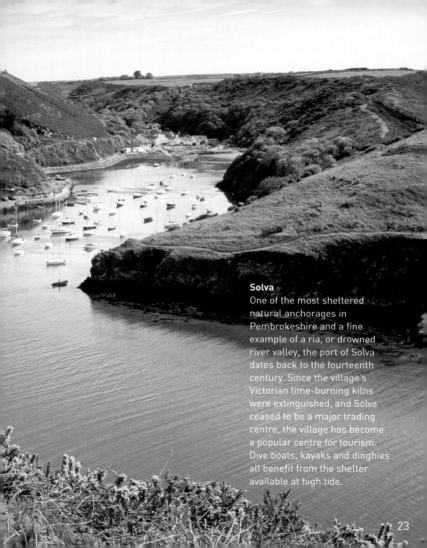

Solva

One of the most sheltered natural anchorages in Pembrokeshire and a fine example of a ria, or drowned river valley, the port of Solva dates back to the fourteenth century. Since the village's Victorian lime-burning kilns were extinguished, and Solva ceased to be a major trading centre, the village has become a popular centre for tourism. Dive boats, kayaks and dinghies all benefit from the shelter available at high tide.

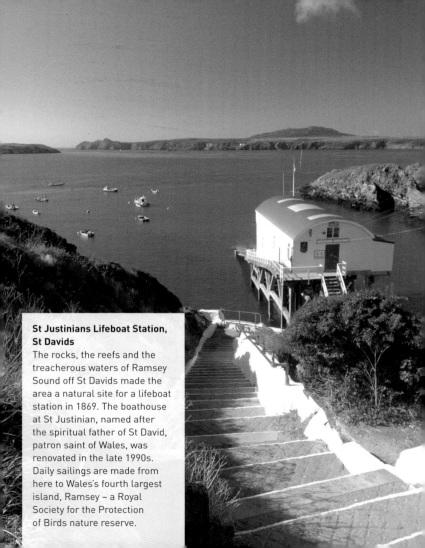

St Justinians Lifeboat Station, St Davids

The rocks, the reefs and the treacherous waters of Ramsey Sound off St Davids made the area a natural site for a lifeboat station in 1869. The boathouse at St Justinian, named after the spiritual father of St David, patron saint of Wales, was renovated in the late 1990s. Daily sailings are made from here to Wales's fourth largest island, Ramsey – a Royal Society for the Protection of Birds nature reserve.

Porthclais, near St Davids in Pembrokeshire

Pembrokeshire's clear blue waters are a magnet for divers, sailors and kayakers and the tiny port of Porthclais, on St Bride's Bay, is a popular launching point. Porpoises and grey seals share the coastline with pleasure boaters, but are upstaged by grey seal cubs in the autumn. In springtime the cliffs, heath and grassland surrounding Porthclais are no less colourful, dotted with wild flowers such as thrift, squill, thyme and campion.

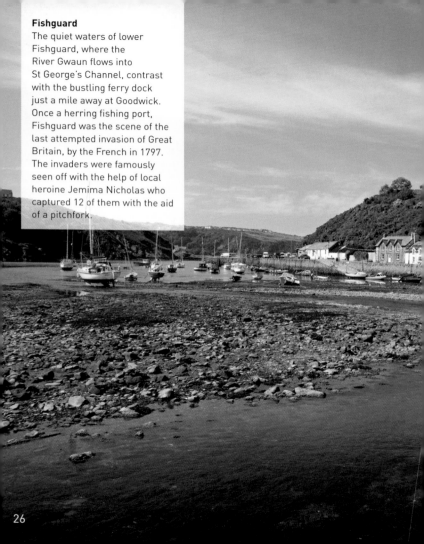

Fishguard
The quiet waters of lower
Fishguard, where the
River Gwaun flows into
St George's Channel, contrast
with the bustling ferry dock
just a mile away at Goodwick.
Once a herring fishing port,
Fishguard was the scene of the
last attempted invasion of Great
Britain, by the French in 1797.
The invaders were famously
seen off with the help of local
heroine Jemima Nicholas who
captured 12 of them with the aid
of a pitchfork.

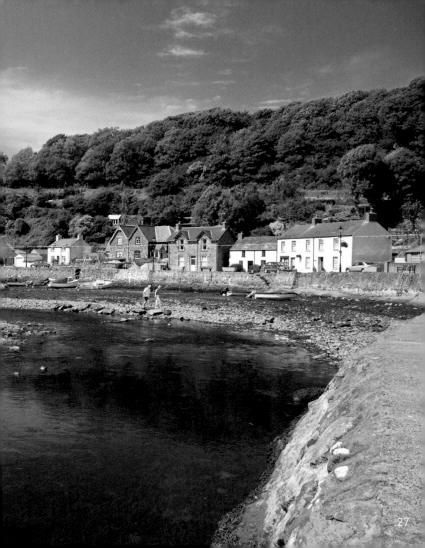

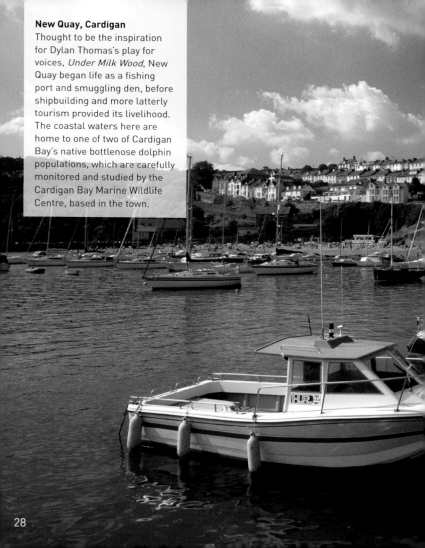

New Quay, Cardigan

Thought to be the inspiration for Dylan Thomas's play for voices, *Under Milk Wood*, New Quay began life as a fishing port and smuggling den, before shipbuilding and more latterly tourism provided its livelihood. The coastal waters here are home to one of two of Cardigan Bay's native bottlenose dolphin populations, which are carefully monitored and studied by the Cardigan Bay Marine Wildlife Centre, based in the town.

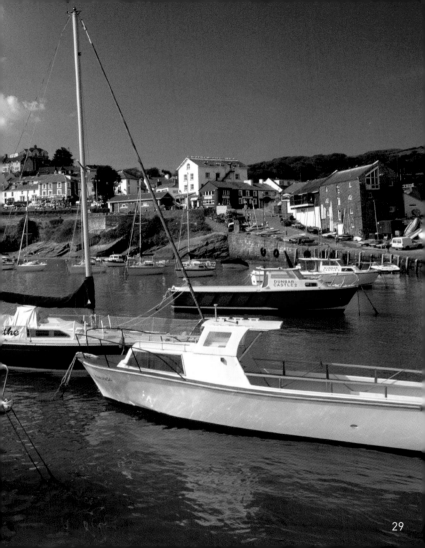

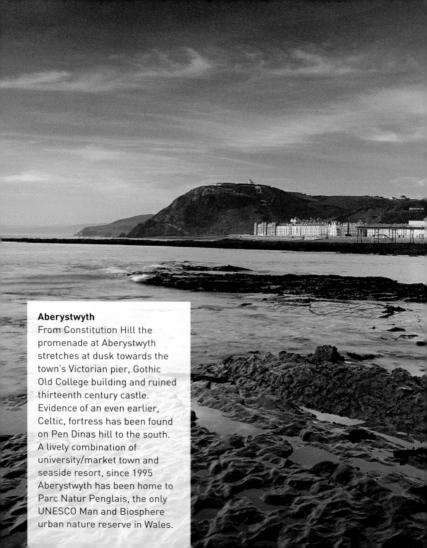

Aberystwyth

From Constitution Hill the promenade at Aberystwyth stretches at dusk towards the town's Victorian pier, Gothic Old College building and ruined thirteenth century castle. Evidence of an even earlier, Celtic, fortress has been found on Pen Dinas hill to the south. A lively combination of university/market town and seaside resort, since 1995 Aberystwyth has been home to Parc Natur Penglais, the only UNESCO Man and Biosphere urban nature reserve in Wales.

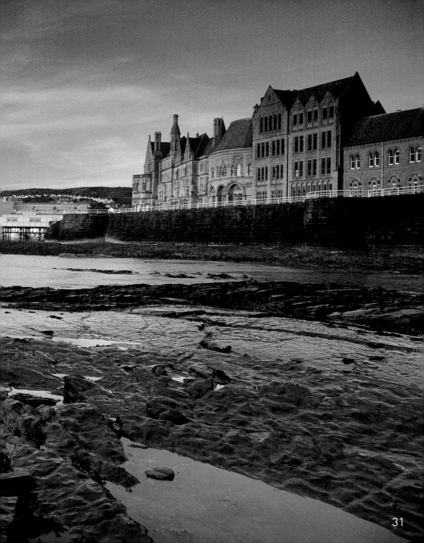

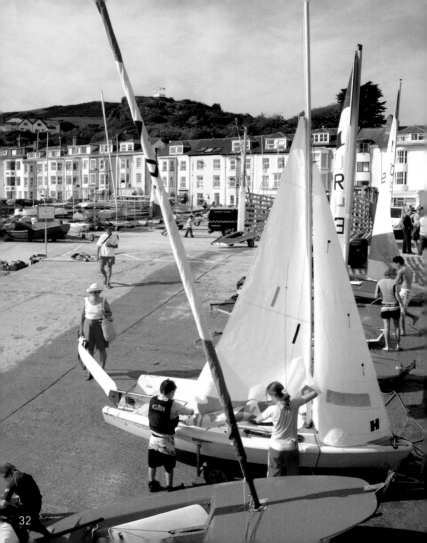

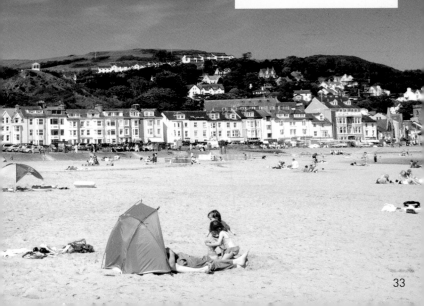

Aberdovey

Each July sailors flock to the popular seaside resort of Aberdovey for the Dovey Regatta Fortnight, but the town's Championship links golf course and four miles of dune-backed sands stretching north towards Tywyn provide plenty of other reasons to holiday here. Legend has it that from Aberdovey the bells of the submerged kingdom of Cantre'r Gwaelod can be heard ringing beneath the waves – a myth which has inspired many works of literature.

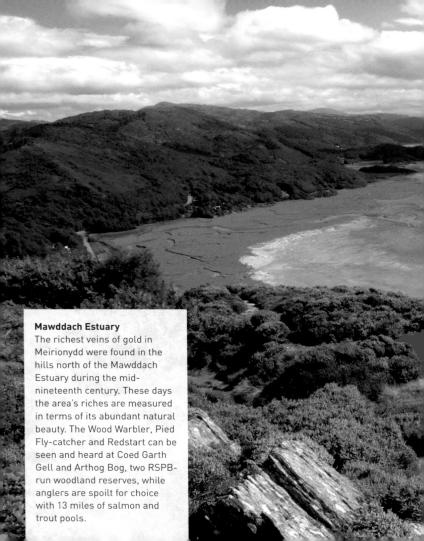

Mawddach Estuary
The richest veins of gold in Meirionydd were found in the hills north of the Mawddach Estuary during the mid-nineteenth century. These days the area's riches are measured in terms of its abundant natural beauty. The Wood Warbler, Pied Fly-catcher and Redstart can be seen and heard at Coed Garth Gell and Arthog Bog, two RSPB-run woodland reserves, while anglers are spoilt for choice with 13 miles of salmon and trout pools.

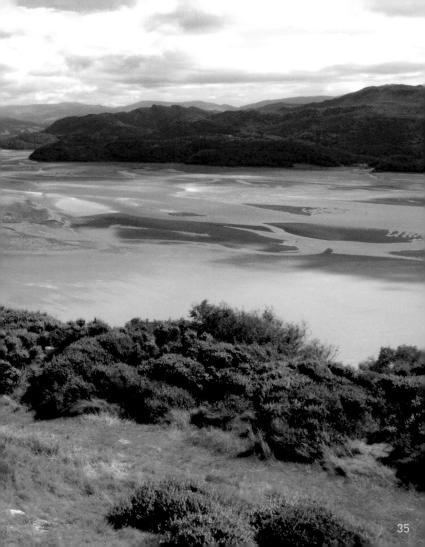

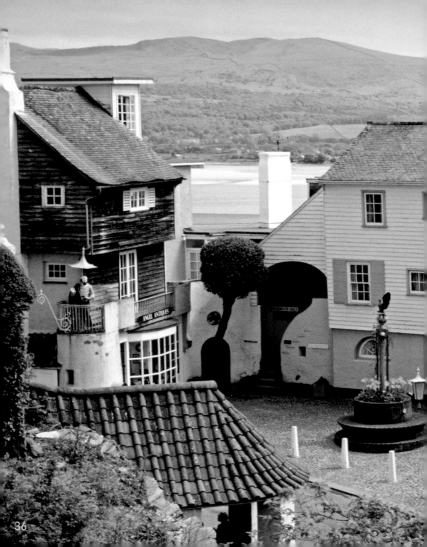

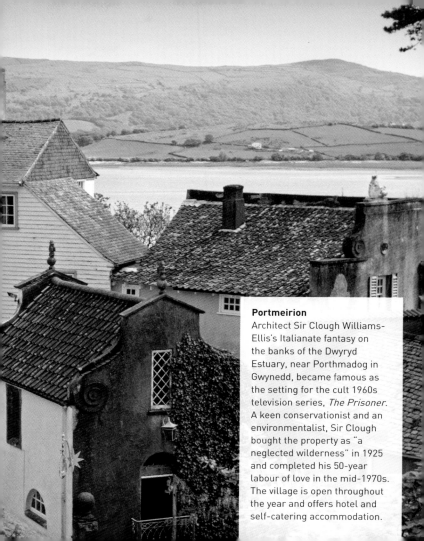

Portmeirion

Architect Sir Clough Williams-Ellis's Italianate fantasy on the banks of the Dwyryd Estuary, near Porthmadog in Gwynedd, became famous as the setting for the cult 1960s television series, *The Prisoner*. A keen conservationist and an environmentalist, Sir Clough bought the property as "a neglected wilderness" in 1925 and completed his 50-year labour of love in the mid-1970s. The village is open throughout the year and offers hotel and self-catering accommodation.

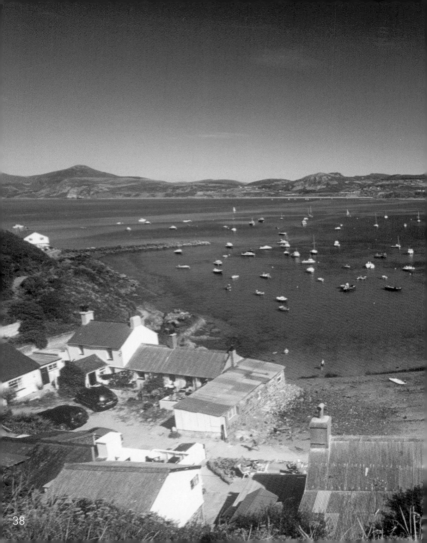

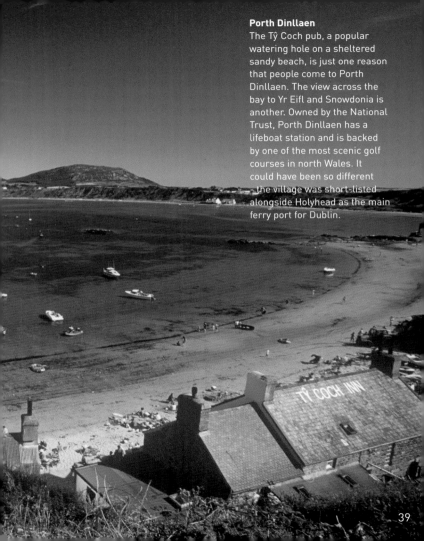

Porth Dinllaen

The Tŷ Coch pub, a popular watering hole on a sheltered sandy beach, is just one reason that people come to Porth Dinllaen. The view across the bay to Yr Eifl and Snowdonia is another. Owned by the National Trust, Porth Dinllaen has a lifeboat station and is backed by one of the most scenic golf courses in north Wales. It could have been so different – the village was short-listed alongside Holyhead as the main ferry port for Dublin.

39

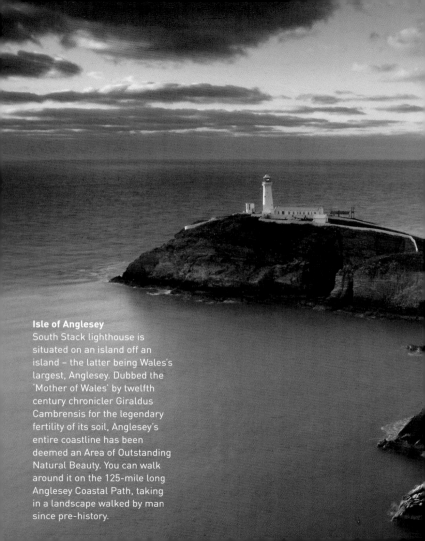

Isle of Anglesey

South Stack lighthouse is situated on an island off an island – the latter being Wales's largest, Anglesey. Dubbed the 'Mother of Wales' by twelfth century chronicler Giraldus Cambrensis for the legendary fertility of its soil, Anglesey's entire coastline has been deemed an Area of Outstanding Natural Beauty. You can walk around it on the 125-mile long Anglesey Coastal Path, taking in a landscape walked by man since pre-history.

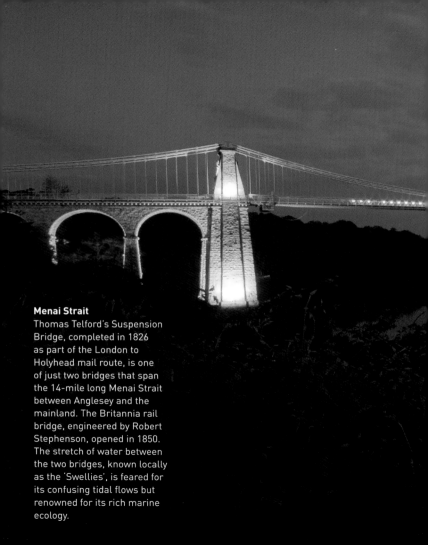

Menai Strait
Thomas Telford's Suspension
Bridge, completed in 1826
as part of the London to
Holyhead mail route, is one
of just two bridges that span
the 14-mile long Menai Strait
between Anglesey and the
mainland. The Britannia rail
bridge, engineered by Robert
Stephenson, opened in 1850.
The stretch of water between
the two bridges, known locally
as the 'Swellies', is feared for
its confusing tidal flows but
renowned for its rich marine
ecology.

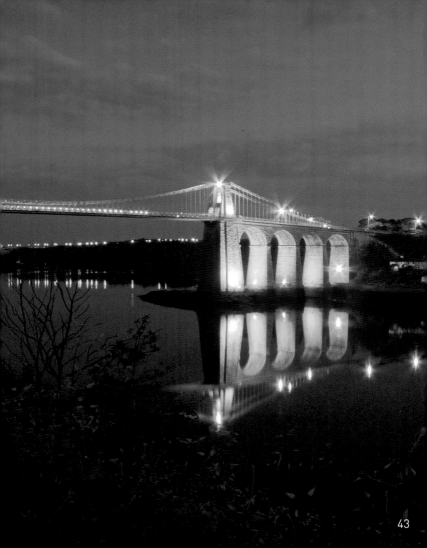

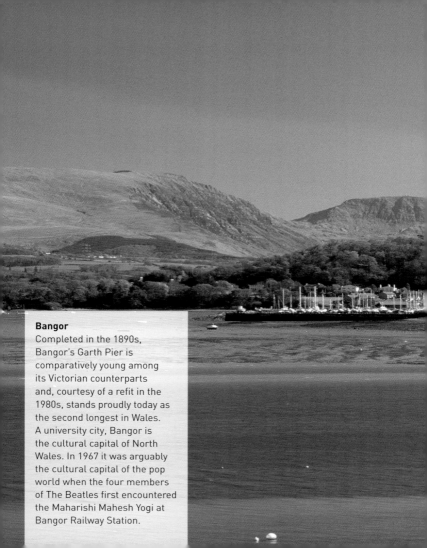

Bangor
Completed in the 1890s, Bangor's Garth Pier is comparatively young among its Victorian counterparts and, courtesy of a refit in the 1980s, stands proudly today as the second longest in Wales. A university city, Bangor is the cultural capital of North Wales. In 1967 it was arguably the cultural capital of the pop world when the four members of The Beatles first encountered the Maharishi Mahesh Yogi at Bangor Railway Station.

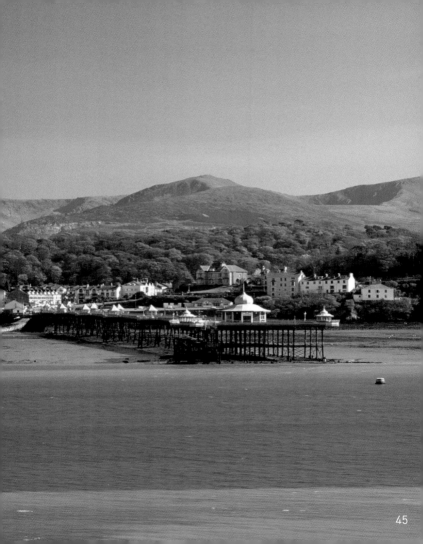

Llandudno

Of all Wales's seaside resorts, Llandudno, in its Victorian and Edwardian grandeur, is surely the most resplendent. At 2,295ft, the town's pier is the longest in Wales and was once a point of departure for the Isle of Man Steam Packet Company. West of the pier rises the Great Orme limestone headland – home to several endangered species of flora and fauna, including the Horseshoe bat and Silver-studded Blue butterfly.

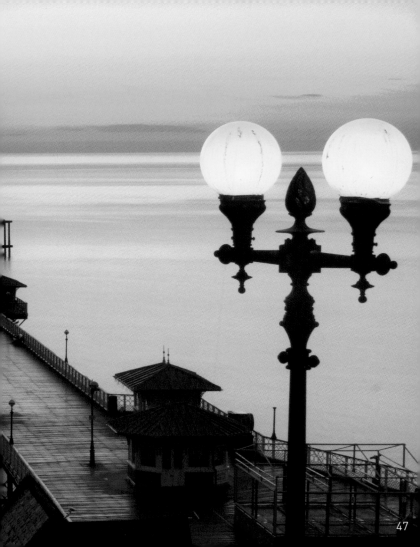

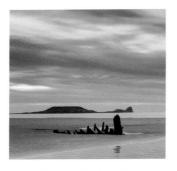

Cover: Wreck of the *Helvetia*
Photo: Billy Stock,
© PhotolibraryWales.com.

Useful websites
www.visitwales.co.uk
www.ccw.gov.uk (National Trails)
www.snowdonia-npa.gov.uk
(Snowdonia National Park)
www.pembrokeshirecoast.org
(Pembrokeshire National Park)
www.visitbreconbeacons.org
(Brecon Beacons National Park)
www.photolibrarywales.co.uk
www.tourwales.org.uk
www.cadw.wales.gov.uk
www.nationaltrust.org.uk
www.graffeg.com

Published by Graffeg
First published 2008
© Graffeg 2008
ISBN 9781905582198

Graffeg, Radnor Court,
256 Cowbridge Road East,
Cardiff CF5 1GZ Wales UK.
www.graffeg.com
are hereby identified as the authors
of this work in accordance with
section 77 of the Copyrights,
Designs and Patents Act 1988.

A CIP Catalogue record for this book
is available from the British Library.

Designed and produced by Peter Gill
& Associates www.petergill.com

Picture credits
© britainonview: NTPL / Joe Cornish:
inside front cover / Paul Clements: 4 /
Doug Mckinlay: 20 / Graham Bell: 25 /
Ian Shaw: 36 / Alan Novelli: 40 / Andy
Stothert: 44. © Peter Gill & Associates:
10, 24, 42, 46. © PhotolibraryWales.com:
3, 6, 8, 12, 14, 16, 18, 21, 22, 26, 28, 30,
32, 33, 34, 38, 48, inside back cover.

www.graffeg.com tel: 029 2037 7312